Draw to Relax

Pretty Patterns
& Soothing Line Art

Draw to Relax

with Guided Meditations
for Calm & Creativity

Words and meditations
by Mary Kate Murray

BETTER DAY BOOKS®

HAPPY · CREATIVE · CURATED

Draw to Relax © 2023 by Better Day Books, Inc.

Publisher: Peg Couch
Book Designer: Llara Pazdan
Editor: Colleen Dorsey

The following images are credited to Shutterstock.com and their respective
creators: exercises 1, 6: Dasha D; exercises 2, 3, 4, 5, 8, 9: Remo_Designer;
exercise 7: art of line; exercise 10: LivDeco; exercise 11: Askhat Gilyakhov; exercise
12: YuliiaOsadcha; exercises 13, 14, 15, 18, 19, 20, 21, 22, 23, 24: Curly Pat; exercise
16: Maliade; exercise 17: Snowman200803; hand (page 7): Videofabrica; wave
texture (chapter 1), lines texture (chapter 2), swirls texture (chapter 3): Curly Pat.
The following image is credited to Freepik.com and its respective creator: paper
texture (pages 10–11, 36–37, 62–63): rawpixel.com.

"Harmony" and "Serenity" text written by Colleen Dorsey.

"Better Day Books," the floral book logo, and "It's a Good Day to
Have a Better Day" are registered trademarks of Better Day Books, Inc.

"Schiffer," "Schiffer Publishing, Ltd.," and the pen and inkwell logo
are registered trademarks of Schiffer Publishing, Ltd.

Library of Congress Control Number: 2022941232

ISBN: 978-0-7643-6544-7
Printed in China
First printing

Copublished by Better Day Books, Inc., and Schiffer Publishing, Ltd.

Better Day Books
P.O. Box 21462
York, PA 17402
Phone: 717-487-5523
Email: hello@betterdaybooks.com
www.betterdaybooks.com
@better_day_books

Schiffer Publishing
4880 Lower Valley Road
Atglen, PA 19310
Phone: 610-593-1777
Fax: 610-593-2002
Email: info@schifferbooks.com
www.schifferbooks.com

This title is available for promotional or commercial use, including special
editions. Contact info@schifferbooks.com for more information.

About the Author

Mary Kate Murray is a lifelong creative, educator, and passionate believer in the healing power of art. She is a founder of the Owlchemy cooperative learning community and the Journeyworks Art Therapy workshop. After 30 years as a teacher, trainer, and corporate process facilitator, Mary Kate has become a marriage and family therapist, currently working with families experiencing addiction. She resides with her family in Columbia, Maryland, where, in addition to her psychotherapy work, she homeschools and participates in community programs.

1

If we all did the things we are really capable of doing, we would literally astound ourselves.
—THOMAS A. EDISON

ABILITY

When we are not okay with failing, we are far less likely to stretch and try something new. But what if failure was just information about how to do something better the next time? What achievement might we grow into? What capabilities might we discover in ourselves?

CONNECT THE DOTS

Start your continuous line drawing at the COLORED dot and continue to complete the image at the BLACK dot.

19

Joy is what happens to us when w allow ourselves to recognize ho good things really are.
—MARIANNE WILLIAMSON

JOY

You have the capacity for joy. Sometimes you may feel everything you do. Other times you may notice it is not wit Where did it go? Know that although joy sometimes pas it is always available to return. Joy does not have to be gr and life-changing. Seek joy in the small details of life. Emb joy fully when it visits you, and await its return faithfully when you don't feel it.

STEP BY

31

The ache for home lives in all of us, the safe place where we can go as we are and not be questioned.
—MAYA ANGELOU

TRUST

Trust is more precious than gold. The ability to truly rest within relationships is a gift beyond measure. How beautiful it is to notice the trust that is given to us and that we give to those we love.

21

I have seen what a laugh can do. It can transform almost unbearable tears into something bearable, even hopeful.
—BOB HOPE

LAUGHTER

Laughter really is the best medicine. It releases all sorts of wonderful brain chemicals and improves your psychological and physical health. Do you make intentional time for laughter, like watching a funny movie or talking to a funny friend? Do you make sure that every week you are doing something that makes you laugh and lightens your load?

Ste

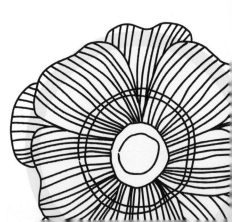

Relax and Unwind

Guided Drawing Meditations in Three Styles

There is a powerful connection between the hand and mind. If you have ever daydreamed while doodling, you have experienced it! The focused concentration of drawing decorative pictures, the rocking motion of drawing repetitive patterns, and the swaying motion of drawing continuous lines over and over again can be both soothing and calming. Drawing allows our minds to be mildly engaged, but not overburdened. And, when we are in this state, we release stress and begin to relax—similar to meditation.

Inside this book you will find 32 drawing exercises (in three different styles) specifically designed for this purpose. There are Continuous Line Patterns to help you unwind, Repetitive Patterns to help you relax, and step-by-step Decorative Patterns to help you with concentration.

Each exercise includes instructions, room to trace the pattern, and a practice area for your own drawing. Also included are guided meditations in the form of key words for you to ponder as you draw, inspirational quotes, and short prompts or takeaway actions. Think about these things as you draw and let your rhythm slow.

Remember, this is not about perfection and drawing like an artist. It is about exploring your own creativity as you relax your mind and body.

Let's get started!

STEP BY STEP

Step 1

Step 2

Repetitive Patterns to help you relax

STEP BY STEP

Step 1

Step 2

Step 3

YOU TRY

Trace on the samples below.

Freehand the design in the available space below.

.

As I draw, I ask myself what the funniest thing was that happened to me all week.

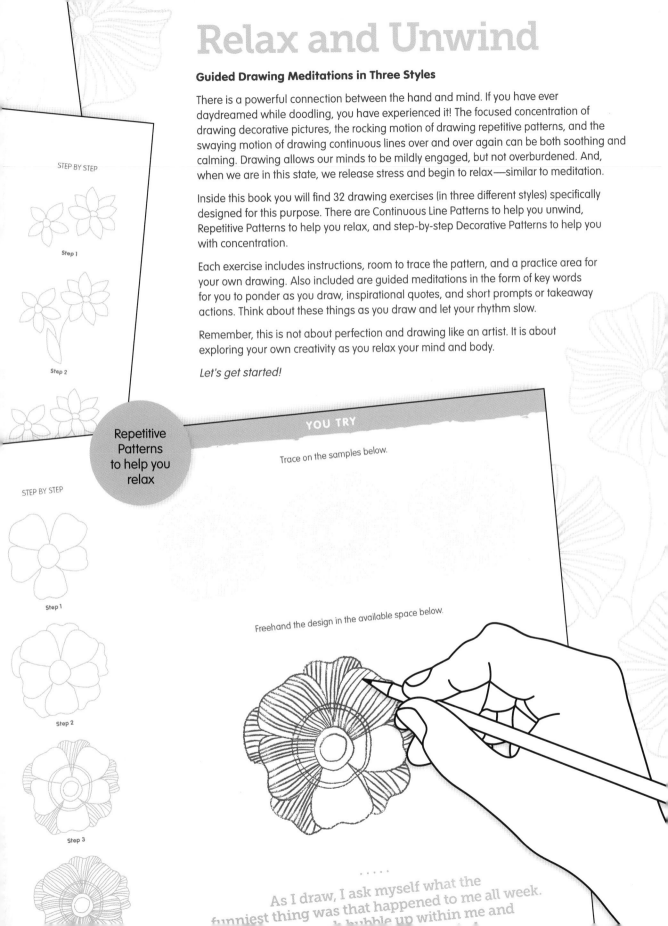

CONTENTS

Follow the color coding to find each style of drawing.

CONTINUOUS LINE PATTERNS

REPETITIVE PATTERNS

DECORATIVE PATTERNS

12

14

24

26

38

40

50

52

64

68

72

76

16

18

20

22

28

30

32

34

42

44

46

48

54

56

58

60

80

84

88

92

CONTINUOUS LINE PATTERNS

These flowing one-line designs allow you, essentially, to relinquish control. You aren't mentally structuring a drawing in your head or lifting the pencil up and down and making decisions about what bit to draw next. Rather, you place your pencil point to the paper and simply follow the path. For these designs, the tracing area is key, since it allows your hand to feel the flow of a design several times before you try it yourself in the blank space.

Release control and allow creativity to guide you.

If we all did the things we are
really capable of doing, we would
literally astound ourselves.
—THOMAS A. EDISON

ABILITY

When we are not okay with failing, we are far less likely
to stretch and try something new. But what if failure was just
information about how to do something better the next time?
What achievement might we grow into? What capabilities
might we discover in ourselves?

CONNECT THE DOTS

**Start your continuous line
drawing at the COLORED dot
and continue to complete the
image at the BLACK dot.**

Trace on the samples below.

Freehand the design in the available space below.

· · · · ·

As I draw, I envision myself as capable.
I meditate on my strengths and
allow myself to be open to the possibilities of
what other capabilities I can cultivate.

· · · · ·

The key to abundance is meeting limited circumstances with unlimited thoughts.
— MARIANNE WILLIAMSON

ABUNDANCE

Abundance can be yours. As you work on this drawing exercise, think about what you would like to draw into your life. It's easy to think we need a lot, but challenge yourself to think about what's most important. Who are you authentically? Where do you wish to be? Who do you want to spend time with? What is the work you feel most called to do? This is the abundant life.

CONNECT THE DOTS

Start your continuous line drawing at the COLORED dot and continue to complete the image at the BLACK dot.

Trace on the samples below.

Freehand the design in the available space below.

· · · · ·

I know myself as abundant.
I envision myself filled with warmth,
comfort, and resources.

· · · · ·

To be yourself in a world that is constantly trying to make you something else is the greatest accomplishment.
—RALPH WALDO EMERSON

ACCOMPLISHMENT

There are many ways to define success. But the most important definition is yours. What do you most dearly want to accomplish? What steps can you take starting today?

CONNECT THE DOTS

Start your continuous line drawing at the **COLORED** dot and continue to complete the image at the **BLACK** dot.

Trace on the samples below.

Freehand the design in the available space below.

.

As I draw, I reflect on my most valued
accomplishments, and I commit to
always giving myself meaningful
goals to undertake.

.

*She never felt ready, but she was brave,
and the universe responds to brave.*
—REBECCA RAY

BRAVERY

There is no bravery without fear. The definition of bravery is doing something you are afraid of. Trusting that you can tolerate the fear is key, but you may need support to feel that trust. What resources can you put in place that will help you feel braver? Is it a friend? Is it taking the brave step on behalf of someone else? Put those supports in place so that you can take action.

CONNECT THE DOTS

Start your continuous line drawing at the COLORED dot and continue to complete the image at the BLACK dot.

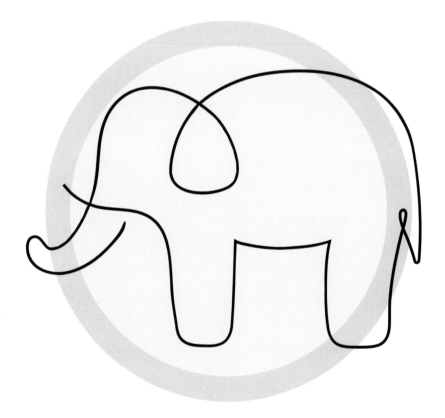

Trace on the samples below.

Freehand the design in the available space below.

· · · · ·

As I draw, I know myself as brave.
I meditate on what can support my bravery,
and I resolve to bring that support to me.

· · · · ·

Your calm mind is the ultimate weapon against your challenges. So, relax.
—BRYANT MCGILL

CALM

Telling someone to calm down rarely works, even when we tell ourselves. But the surest way to calm a racing mind is through the breath. Box breathing is a powerful, yet simple, relaxation technique. Breathe in on a count to four. Hold your breath on a count to four. And exhale on a count to four. If it feels right, you can lengthen the time, but make sure to keep them all the same. Repeat this until you feel calmer, anywhere from three cycles to four or more minutes.

CONNECT THE DOTS

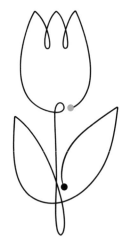

Start your continuous line drawing at the COLORED dot and continue to complete the image at the BLACK dot.

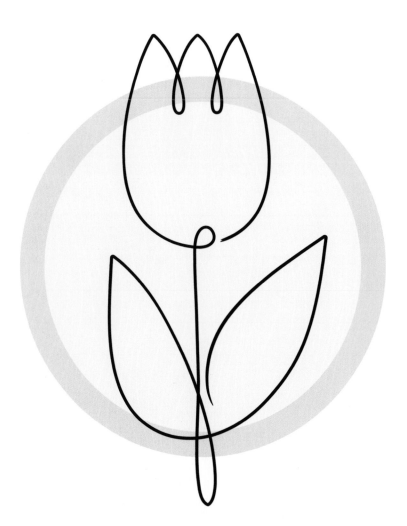

Trace on the samples below.

Freehand the design in the available space below.

· · · · ·

As I draw, I notice my breath and consciously create a box with it. I breathe in, hold the breath, and breathe out in a measured fashion. I notice the energy in my mind and body feeling more peaceful.

· · · · ·

Words of comfort, skillfully administered, are the oldest therapy known to man.
—LOUIS NIZER

COMFORT

When we are fearful or anxious, it is so comforting to be able to pour out the words in our hearts into the ears and arms of a trusted friend. What a blessing it is to have loving relationships in our lives to comfort us.

CONNECT THE DOTS

Start your continuous line drawing at the COLORED dot and continue to complete the image at the BLACK dot.

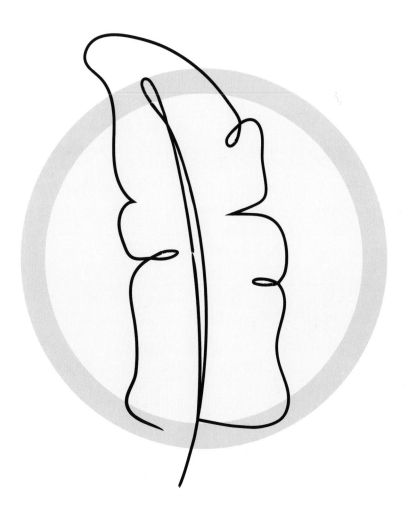

Trace on the samples below.

Freehand the design in the available space below.

.

As I draw, I reflect on the comforting
love that surrounds me. I am deeply grateful
for its presence in my life.

.

If you want others to be happy, practice compassion. If you want to be happy, practice compassion.
—DALAI LAMA, XIV

COMPASSION

It is said that people need compassion the most when they are acting the worst. This is also true for ourselves. But being compassionate (whether to ourselves or others) during difficult times can be hard. The key is to look for understanding. If we can set healthy limits and know that each of us is just trying to get our needs met, we can escape the "blame game" and see situations in a different light—without judgment.

CONNECT THE DOTS

Start your continuous line drawing at the COLORED dot and continue to complete the image at the BLACK dot.

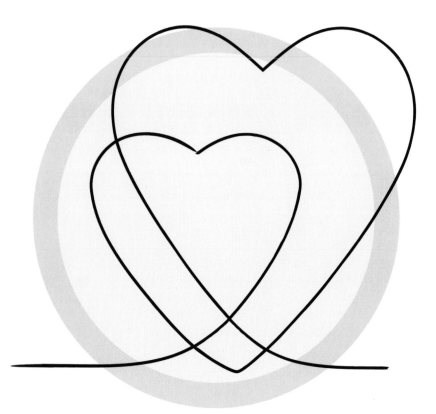

Trace on the samples below.

Freehand the design in the available space below.

.

As I draw, I set my intention to be
my own best friend. I vow to approach
making changes from
a place of self-compassion.

.

Confidence comes not always from being right, but from not fearing to be wrong.
—PETER T. MCINTYRE

CONFIDENCE

If we can make peace with failure (perhaps not even seeing it as failure, but as a learning opportunity), we can take more-thoughtful risks. When there is more room to try (or take risks), we stretch our wings and do more things. The more we do, the more we learn. This builds our abilities and confidence.

CONNECT THE DOTS

Start your continuous line drawing at the COLORED dot and continue to complete the image at the BLACK dot.

Trace on the samples below.

Freehand the design in the available space below.

· · · · ·

As I draw, I meditate on the
notion that I am allowed to try and fail
and learn and grow. I know myself as skilled at
this process and I see myself as confident.

· · · · ·

If you are willing to do something that might not work, you are closer to being an artist.
—SETH GODIN

CREATIVITY

All children are creative, without exception. If you visit a preschool classroom, there are no three-year-olds saying, "I'm just not good at painting." They simply paint and are often unattached to their work. Somewhere along the way, we learn to be afraid that our creativity is not "good enough." What if we use that three-year-old as a model and just paint, or draw, or collage, or work in whatever medium we are drawn to? What if we created without judgment?

CONNECT THE DOTS

Start your continuous line drawing at the COLORED dot and continue to complete the image at the BLACK dot.

Trace on the samples below.

Freehand the design in the available space below.

.

As I draw, I invite my inner art critic
to enjoy a nap elsewhere. I allow myself to create
unselfconsciously and without expectation, enjoying
the present moment of the simple act of creating.

.

I think at a child's birth, if a mother could ask a fairy godmother to endow it with the most useful gift, that gift should be curiosity.

—ELEANOR ROOSEVELT

CURIOSITY

How easy it is to get caught up in external forces in our lives: deadlines, commitments, obligations, and the needs of others. How easy it is to lose touch with ourselves and what we feel, need, and want, and what our path looks like at any given time. How can you notice yourself today?

CONNECT THE DOTS

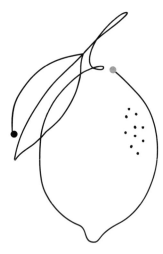

Start your continuous line drawing at the COLORED dot and continue to complete the image at the BLACK dot.

Trace on the samples below.

Freehand the design in the available space below.

.

As I draw, I slow down and notice
myself with gentle curiosity. I ask myself
what I need right now.

.

*Be faithful in small things because
it is in them that your strength lies.*
—MOTHER TERESA

FAITH

We all need convictions to believe in. It is important to spend time in our lives deciding what those things are. What do you have faith in? What moves you? In what beliefs do you place your confidence?

CONNECT THE DOTS

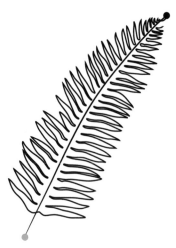

Start your continuous line drawing at the COLORED dot and continue to complete the image at the BLACK dot.

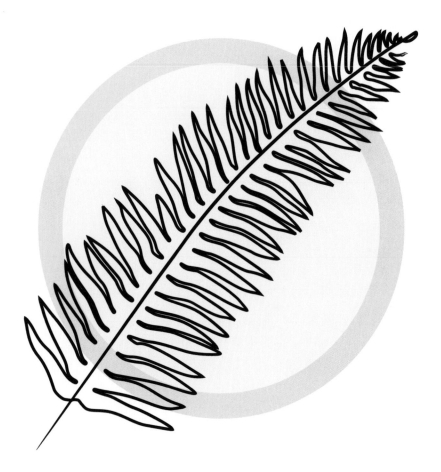

Trace on the samples below.

Freehand the design in the available space below.

· · · · ·

As I draw, I meditate on those convictions
I most dearly value. I ask myself if I am aligning
with my closest-held beliefs.

· · · · ·

*You are the sky; everything else
is just the weather.*
—PEMA CHÖDRÖN

FOCUS

Focus allows us to work in a mindful way. It opens up creativity
and increases our level of engagement. Being able to focus
on a singular task allows us to decrease stress and increase
satisfaction. What distracts you from focus?

CONNECT THE DOTS

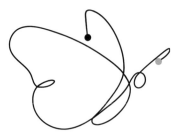

**Start your continuous line
drawing at the COLORED dot
and continue to complete the
image at the BLACK dot.**

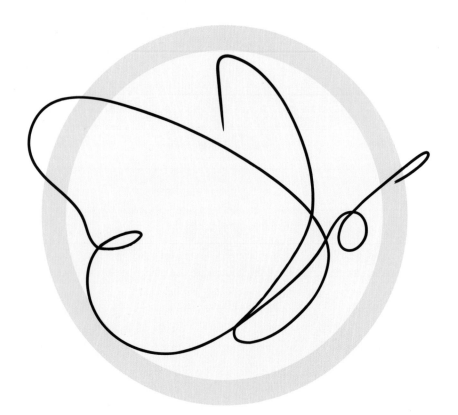

Trace on the samples below.

Freehand the design in the available space below.

.

I give myself permission
to silence my phone temporarily so
that I may focus on my task.

.

REPETITIVE PATTERNS

The calm-inducing designs in this section use
repetition to encourage a meditative state.
Each repeated stroke of your pencil creates a
comfortable groove, in two senses of the word:
a physical groove that your pencil and pen
can fit into and repeat, and a mental groove of
getting in the zone as you draw. The end result
for each design looks lush and beautiful with
neat, parallel, structured lines.

*Harness the power of repetition
to create lovely illustrations.*

*Between stimulus and response,
there is a space. In that space is our power
to choose our response. In our response
lies our growth and our freedom.*

—VIKTOR EMIL FRANKL

FREEDOM

What a powerful truth it is that we have freedom of choice.
We have so many external influences on our thoughts and
decisions that it behooves us to examine our choices and make
sure that we are deciding for ourselves. How do you experience
your freedom? What satisfaction do you derive from knowing
your own mind and making your own choices?

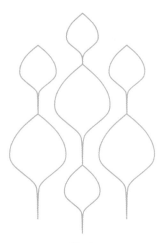

Step 1

Step 2

Step 3

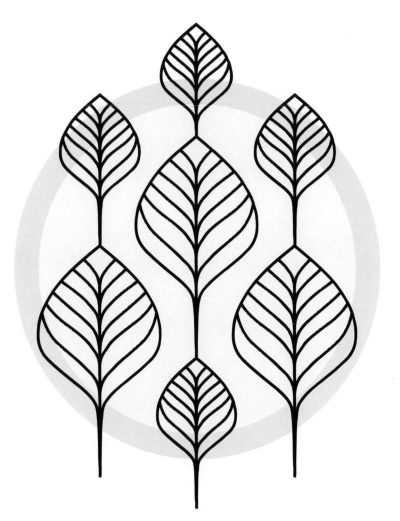

Trace on the samples below.

Freehand the design in the available space below.

· · · · ·

As I draw, I reflect on my freedom
of choice and all the gifts
that I derive from fully owning it.

· · · · ·

The Buddha taught that anyone who experiences the delight of being truly generous will never want to eat another meal without sharing it.
—MARTHA BECK

GENEROSITY

It is easy to feel like giving to others will take from us. But what if we intentionally find ways in which we can be generous and notice how those ways feed us rather than impoverish us? Maybe you can designate a set amount of funds each month to donate. Maybe you can decide to donate some of your time each month to a cause that feels meaningful to you. Maybe you can check in on someone who might need your help.

Step 1

Step 2

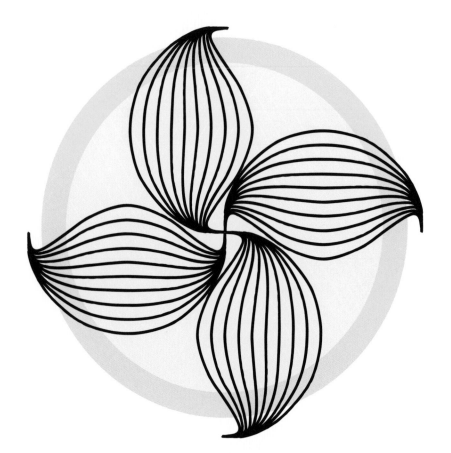

Step 3

Step 4

Trace on the samples below.

Freehand the design in the available space below.

.

As I draw, I wonder deeply how
I might be generous. I know that giving
in a healthy way can feed me deeply.

.

Gratitude is a powerful catalyst for happiness. It's the spark that lights a fire of joy in your soul.

—AMY COLLETTE

GRATITUDE

Our brains are wired to notice what is wrong. That skill helped us run from saber-toothed tigers, but it does not help us see the happiness available to us every day. Focusing on all the gifts that we have in our lives fills our reservoirs. Do you feed your heart with gratitude? Can you list five things that you are grateful for right now?

Step 1

Step 2

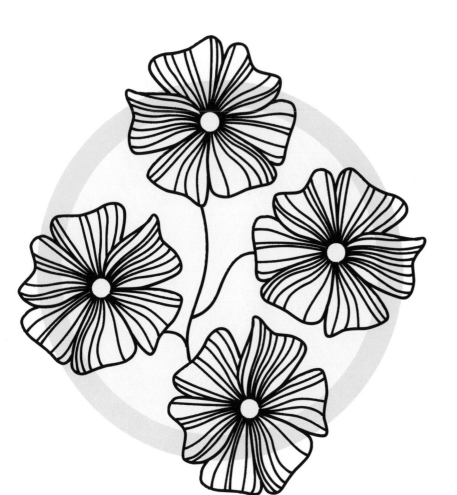

Step 3

Trace on the samples below.

Freehand the design in the available space below.

· · · · ·

As I draw, I focus on all that
I am grateful for. As I sit with my blessings,
I feel the warmth in my heart that then
spreads through my whole body.

· · · · ·

Always aim at complete harmony of thought and word and deed. Always aim at purifying your thoughts and everything will be well.
—MAHATMA GANDHI

HARMONY

To cultivate harmony, we must be mindful and conscious of our deepest selves and work to realign our thoughts and actions when they begin to conflict. When we act in accordance with our beliefs, when we build our lives in keeping with our highest values, we find harmony, which fills us with both energy and peace.
In what ways could you bring various elements of your life into greater congruence?

STEP BY STEP

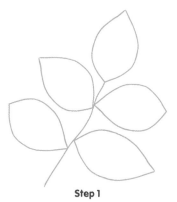

Step 1

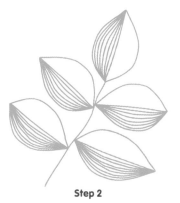

Step 2

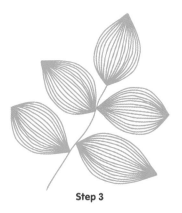

Step 3

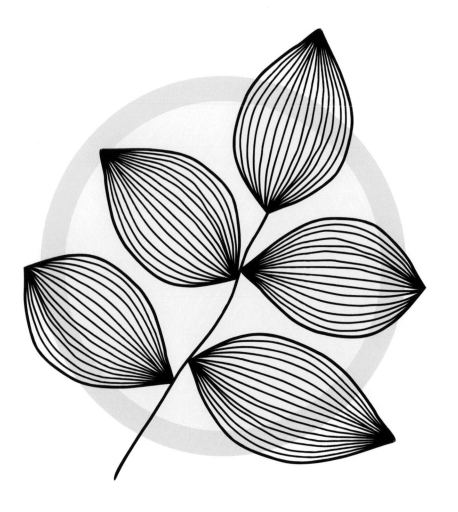

Trace on the samples below.

Freehand the design in the available space below.

· · · · ·

As I draw, I give myself permission
to live courageously according to my
beliefs so that that I may experience
the gift of harmony.

· · · · ·

Hope begins in the dark, the stubborn hope that if you just show up and try to do the right thing, the dawn will come. You wait and watch and work. You don't give up.

—ANNE LAMOTT

HOPE

Hope can feel like a passive act. But it can sometimes be a brave act of faithfulness and rebellion when it would seem that hope is foolish. If we cultivate a hopeful outlook on our lives, it means believing that things will work for our good.

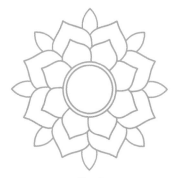

Step 1

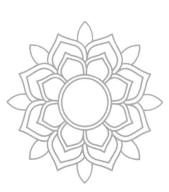

Step 2

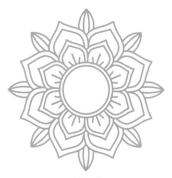

Step 3

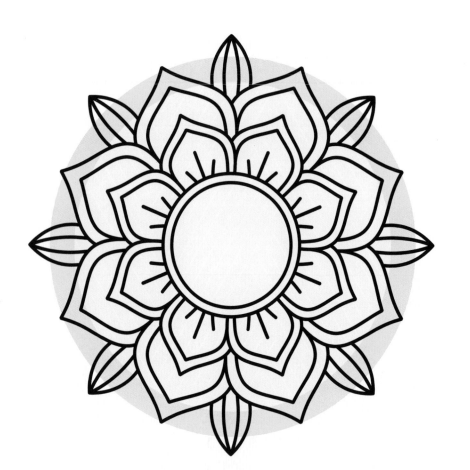

Trace on the samples below.

Freehand the design in the available space below.

· · · · ·

As I draw, I know myself to be a
hopeful person. I commit myself to the notion
that my life conspires for my good.

· · · · ·

A heart without dreams is like
a bird without feathers.
—SUZY KASSEM

IMAGINATION

Allowing our hearts to dream is perhaps one of the most precious things about being human. Having dreams can protect us from hopelessness in the way that a bird's feathers protect them from the elements. This ability to imagine or dream about our future is what propels us to try new things. Do you allow yourself time to explore your imagination?

STEP BY STEP

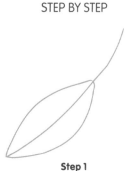

Step 1

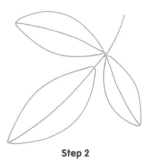

Step 2

Step 3

(Repeat steps 1–3)

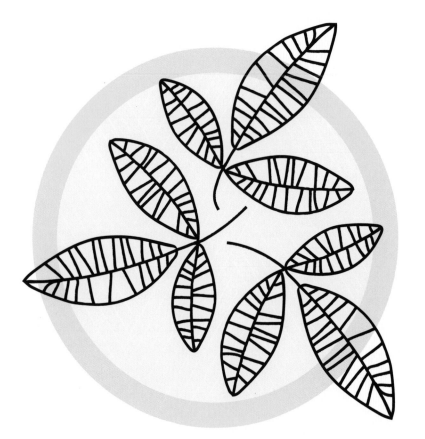

Trace on the samples below.

Freehand the design in the available space below.

· · · · ·

As I draw, I allow myself to dream
about what I really hope to create
in my life. I imagine what life will be like
when those dreams come to be.

· · · · ·

Joy is what happens to us when we allow ourselves to recognize how good things really are.
—MARIANNE WILLIAMSON

JOY

You have the capacity for joy. Sometimes you may feel it in everything you do. Other times you may notice it is not with you. Where did it go? Know that although joy sometimes passes, it is always available to return. Joy does not have to be grand and life-changing. Seek joy in the small details of life. Embrace joy fully when it visits you, and await its return faithfully when you don't feel it.

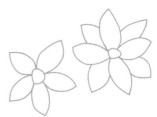

Step 1

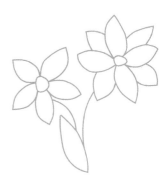

Step 2

Step 3

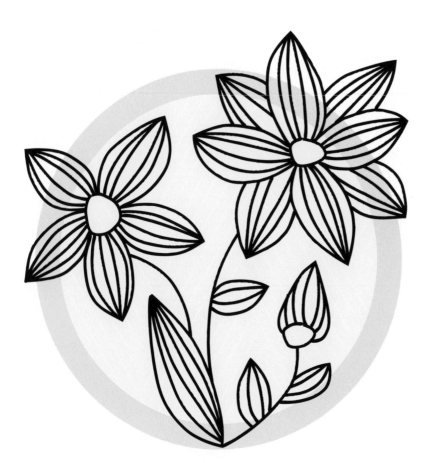

Step 4

Trace on the samples below.

Freehand the design in the available space below.

· · · · ·

As I draw, I know myself as
a joyful person. I give myself over fully to the
warm and delicious energy of joy.

· · · · ·

Step 1

Love and kindness are never wasted. They always make a difference. They bless the one who receives them, and they bless you, the giver.
—BARBARA DE ANGELIS

KINDNESS

When we turn our kindness toward another, we become a conduit for goodness. Our giving brings us so much. What gifts can you give today?

Step 2

Step 3

Step 4

Trace on the samples below.

Freehand the design in the available space below.

.

As I draw, I contemplate my gifts and
how they might serve. I know that my giving
will feed me as it serves others.

.

I have seen what a laugh can do. It can transform almost unbearable tears into something bearable, even hopeful.

—BOB HOPE

LAUGHTER

Laughter really is the best medicine. It releases all sorts of wonderful brain chemicals and improves your psychological and physical health. Do you make intentional time for laughter, like watching a funny movie or talking to a funny friend? Do you make sure that every week you are doing something that makes you laugh and lightens your load?

Step 1

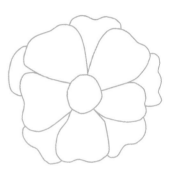

Step 2

Step 3

Step 4

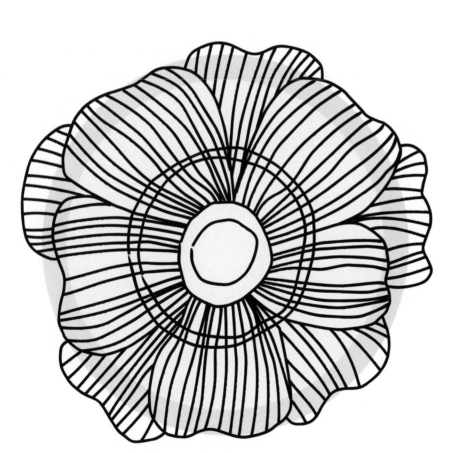

Trace on the samples below.

Freehand the design in the available space below.

· · · · ·

As I draw, I ask myself what the
funniest thing was that happened to me all week.
I feel the laugh bubble up within me and
notice how much lighter I feel.

· · · · ·

22

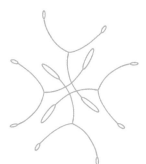

Step 1

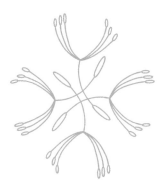

Step 2

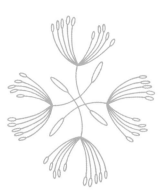

Step 3

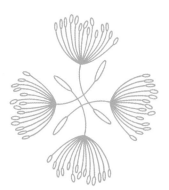

Step 4

*Love is a light that shines
from heart to heart.*
—JOHN DENVER

LOVE

Putting energy into what best supports our health, happiness, and
well-being is a lifelong goal that we return to again and again as
our lives ebb and flow. How can we call in love and light into our
lives? Think about whom you most love and what you wish to be
loved for as you practice this drawing exercise.

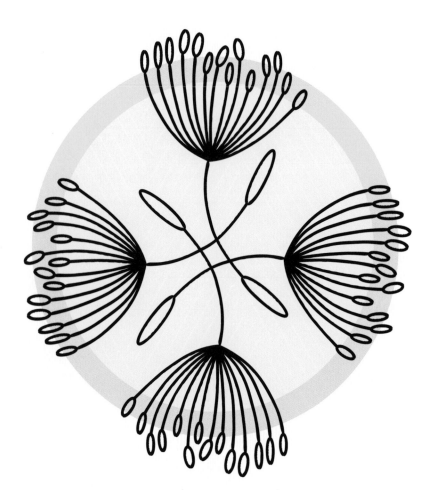

Trace on the samples below.

Freehand the design in the available space below.

· · · · ·

May the love and light
within me radiate out from me.

· · · · ·

Death is not the greatest loss in life.
The greatest loss is what dies
inside us as we live.
—NORMAN COUSINS

PASSION

The flow of passion within us can sometimes be blocked by the stresses of life. We can lose track of the spark in us that powers our deepest desires and dreams. It is so important to take time in life to wonder about our passions and make sure we are keeping them alive. What are you passionate about?

STEP BY STEP

Step 1

Step 2

Step 3

(Repeat steps 1–3)

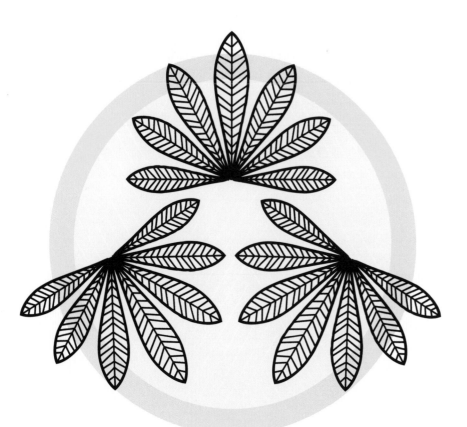

Trace on the samples below.

Freehand the design in the available space below.

.

As I draw, I remind myself to make
space for my passions. I commit to spending
time drawing or journaling about them.

.

*Patience is the calm acceptance
that things can happen in a different order
than the one you have in mind.*
—DAVID G. ALLEN

PATIENCE

Sometimes, the hardest thing to do is be patient. When we notice ourselves feeling impatient, we can use our breath to help calm us. And we can remind ourselves that our idea of how things are supposed to be is perhaps not always the best way for them to be.

STEP BY STEP

Step 1

Step 2

Step 3

Trace on the samples below.

Freehand the design in the available space below.

.

As I draw, I call upon my sense of
inner peace to bring me patience.
I remind myself to have faith that things
will work out as they need to.

.

DECORATIVE PATTERNS

The decorative designs in this section are satisfyingly complex. But don't be deterred by the level of detail—everything is broken down into steps that are easy to follow. Plus, you don't need to exactly replicate the object or the patterning—you can feel free to modify it to your own tastes and vibes. Decorate your art using simple dots, hashes, swirls, scalloping, and whatever else you can imagine.

Also included here are additional pages featuring journaling prompts and space for more drawing. Just as this section of the book delves into more-detailed drawings, so too will you now have the opportunity for more detailed, directed reflection. Use the pages and prompts to dig deeper into your own mind, experiment with recreating the bonus art shown on the pages, or just use the space for further practice of the exercises.

Branch out into creative, unique detail.

Peace. It does not mean to be in a place where there is no noise, trouble, or hard work. It means to be in the midst of those things and still be calm in your heart.
—UNKNOWN

PEACE

It can be tempting to think that the only way for us to feel peaceful is to be somewhere still, quiet, and uninterrupted. And while that is wonderful, it is not always possible. How can we find our calm in the midst of our daily lives?

STEP BY STEP

Step 1

Step 2

Step 3

Trace on the samples below.

Freehand the design in the available space below.

.

As I draw, I inhale fully.
I know myself as calm, centered, and peaceful,
regardless of my circumstances.

.

*The deeper your self-love,
the greater your protection.*
—DANIELLE LAPORTE

PROTECTION

Creating boundaries and protection for our hearts and minds
is critical to our well-being. Do you make sure that the people
in your life have your highest good in mind?

Step 1

Step 2

Step 3

Step 4

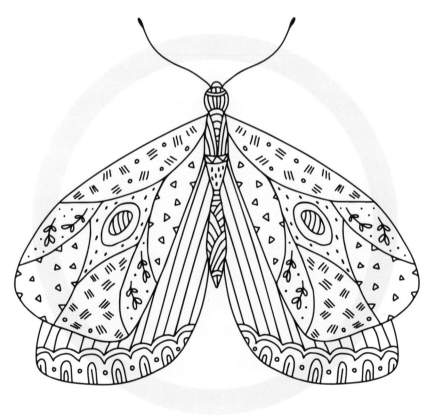

Trace on the samples below.

Freehand the design in the available space below.

· · · · ·

As I draw, I meditate on the boundaries
that are most important to me.
I commit to taking good care of myself
in my relationships.

· · · · ·

All of our great traditions, religious, contemplative, and artistic, say that you must learn how to be alone and have a relationship with silence.
—DAVID WHYTE

QUIET

Sitting in silence, we find whole new worlds of sensation within us. We might hear our breathing. We might feel our tension or relaxation. We might feel peace arise. We might feel sadness arise. It is in the quiet that we meet ourselves.

STEP BY STEP

Step 1

Step 2

Step 3

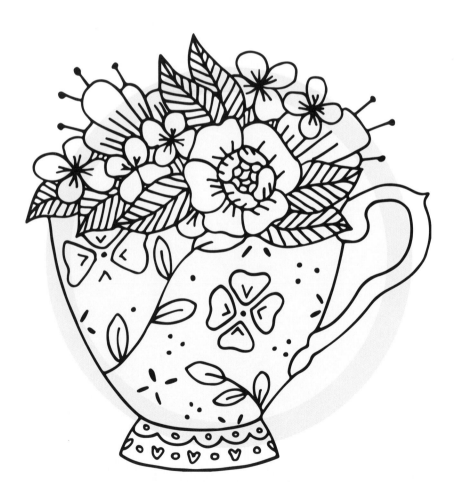

Trace on the samples below.

Freehand the design in the available space below.

· · · · ·

As I draw, I sit in silence.
I notice whatever arises in me, and
I greet it with self-compassion. I take these
moments to know myself more deeply.

· · · · ·

GET CREATIVE AND DRAW
SOME NEW DESIGNS!

God, grant me the serenity to accept the things I cannot change, the courage to change the things I can, and the wisdom to know the difference.

—REINHOLD NIEBUHR

SERENITY

To cultivate serenity is to accept that outside forces may affect your life, that setbacks may occur, and that you may even have disagreements within yourself, but that none of these things defines you or is allowed to disturb your core.

How can you learn to foster serenity?

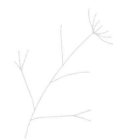

Step 1

Step 2

Step 3

Trace on the samples below.

Freehand the design in the available space below.

· · · · ·

As I draw, I allow all the worries
of the day and of my life to float away
like fading ripples. For this moment,
I am still and serene.

· · · · ·

Step 1

*There is no angry way
to say bubbles.*
—UNKNOWN

SILLINESS

Where we can see humor, there is room for love. Where do you
make space for silliness and lightheartedness in your life?

Step 2

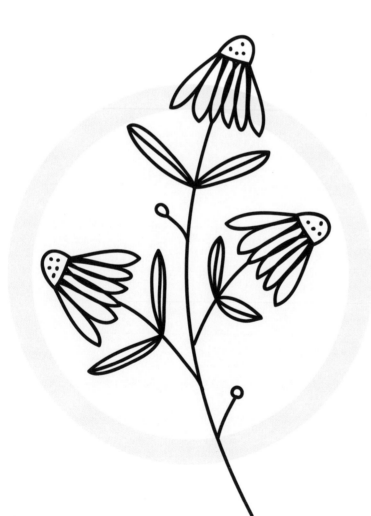

Step 3

Trace on the samples below.

Freehand the design in the available space below.

.

As I draw, I know myself as
filled with lightness, laughter, and joy.
My most important connections bring forth
a happiness that bubbles up within me.

.

You will find that it is necessary to let things go; simply for the reason that they are heavy.

—C. JOYBELL C.

STRESS RELIEF

Stress is all around us. How can we discharge the stress from within us to create more balance and peace? The breath is one of the surest ways to calm yourself. Just three deep, deep breaths can shift the brain into more regulation. Try deep breathing as you work on this drawing exercise.

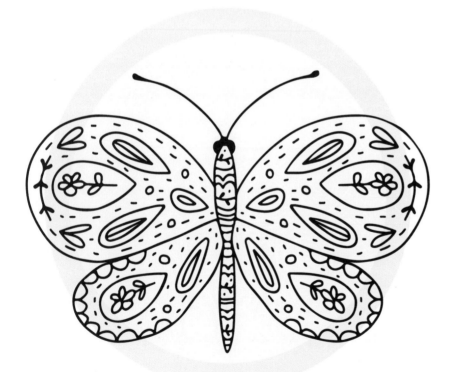

STEP BY STEP

Step 1

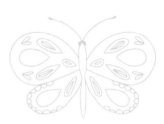

Step 2

Step 3

Step 4

84

Trace on the samples below.

Freehand the design in the available space below.

· · · · ·

I know myself
as peaceful, centered,
and relaxed.

· · · · ·

*The ache for home lives in all of us,
the safe place where we can go as we are
and not be questioned.*

—MAYA ANGELOU

TRUST

Trust is more precious than gold. The ability to truly rest within
relationships is a gift beyond measure. How beautiful it is
to notice the trust that is given to us and that we give
to those we love.

Step 1

Step 2

Step 3

Trace on the samples below.

Freehand the design in the available space below.

· · · · ·

As I draw, I contemplate the trust
that I rest in. I am forever grateful to be
able to trust and be trusted.

· · · · ·

I decided that the most subversive, revolutionary thing I could do is show up for my life and not be ashamed.

—ANNE LAMOTT

WILL

When we stop resisting the lessons that life puts in front of us and instead see them as learning experiences, everything becomes easier. When we approach our lives in a way that is willing to learn whatever we need to learn, then we move more easily through our lessons.

Step 1

Step 2

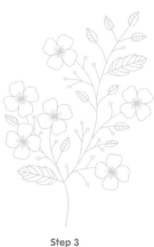

Step 3

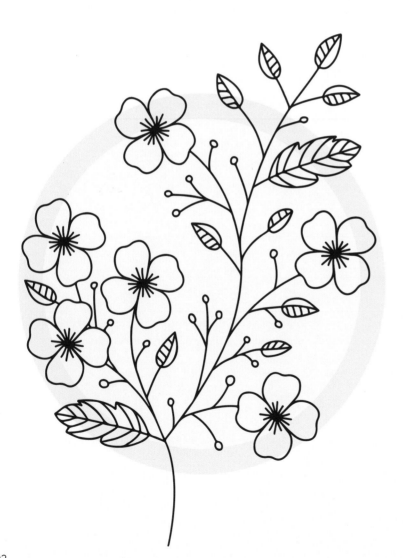

Trace on the samples below.

Freehand the design in the available space below.

.

As I draw, I know myself
as one who is willing to learn and grow.
I have faith that my lessons are
for my greater good.

.

BETTER DAY BOOKS®

HAPPY • CREATIVE • CURATED

Business is personal at Better Day Books. We were founded on the belief that all people are creative and that making things by hand is inherently good for us. It's important to us that you know how much we appreciate your support. The book you are holding in your hands was crafted with the artistic passion of the author and brought to life by a team of wildly enthusiastic creatives who believed it could inspire you. If it did, please drop us a line and let us know about it. Connect with us on Instagram, post a photo of your art, and let us know what other creative pursuits you are interested in learning about. It all matters to us. You're kind of a big deal.

it's a good day to have a better day!®

www.betterdaybooks.com
better_day_books